SOME ARE MORE
THAN OTHERS

ALSO BY STEVIE SMITH

COLLECTED POEMS
NEW SELECTED POEMS

SOME ARE MORE HUMAN
THAN OTHERS

A SKETCHBOOK BY
STEVIE SMITH

FOREWORD BY JAMES MacGIBBON

A NEW DIRECTIONS BOOK

Manufactured in the United States of America
New Directions Books are printed on acid-free paper. *Some Are More Human than Others*
was originally published by Gaberbocchus Press Ltd. in London, England, in 1958. First
published as New Directions Paperbook 680 in 1989. Published simultaneously in Canada
by Penguin Books Canada Limited

LIBRARY OF CONGRESS CATALOGING-IN-PUBLICATION DATA
Smith, Stevie, 1902-1971.
Some are more human than others: sketch-book/by Stevie Smith.
p. cm. Originally published: London: Gaberbocchus, 1958.
ISBN 0-8112-1110-X (alk. paper)
1. Smith, Stevie, 1902-1971 — Notebooks, sketchbooks, etc. I. Title.
PR6037.M43S66 1989 89-8309
828'.91203 — dc20 CIP

New Directions Books are published for James Laughlin
by New Directions Publishing Corporation
80 Eighth Avenue, New York 10011

FOREWORD

In *Some Are More Human than Others* Stevie Smith treats humans and animals as one species, mammals, nearly all equal; only "nearly" though, for her cats and dogs and one pig are usually wiser and more percipient than we humans are. Look for instance at what is probably a Pekingese with a near-human face, pursing its lips to express contempt for the aristocracy, over the caption, "This is rather like Lady Diana"! And what a story must lie behind the vulpine young girl with an inane smile, remarking, *tout court,* "My mother was a fox". Then there is the tragedy of the distraught maiden exclaiming (without the slightest hope, Stevie's drawing implies), "Orestes, when are you coming?". One could go on like this, relishing each page, for every drawing is a withering comment on the human condition—often through the mouths of animals.

Snatches of conversation overheard in the street (and most of the captions suggest this is what we have here) can be very revealing of life—as good short stories are. Sometimes indeed Stevie's captions and drawings are illustrated short stories in themselves. She had the knack of catching these oral gems, storing them in her memory for future use in poems, for she had the ear as well as the eye of a poet. This, her only book to give her drawings full play, also reflects her own conversation, amused, amusing and deliciously barbed in her comments on people and events, elusive as quicksilver. The book is one of the keys to a complex, tirelessly active mind, a pointer to the stuff her poems were made of. New Directions has performed a service for her admirers by reissuing it.

—JAMES MACGIBBON

SOME ARE MORE HUMAN

THAN OTHERS

Someone should speak .

He did not find anything
to make him feel at home.

I never
sleep.

"Adela is such a
silly woman."
"Tom says Adela
is going off her
head."
~~~~~~~~

Adela is staying
down in the country
She is v. happy.

~~~~~~

Doctor Nott is
v. nice.

~~~~~

I am only happy when I am
in England. I am a dreamer.

Athalie
and
Hypatia
chose
to
be
lost.

What is the matter with Ireland now?

Moi, c'est
moralement
que j'ai
mes élégances...

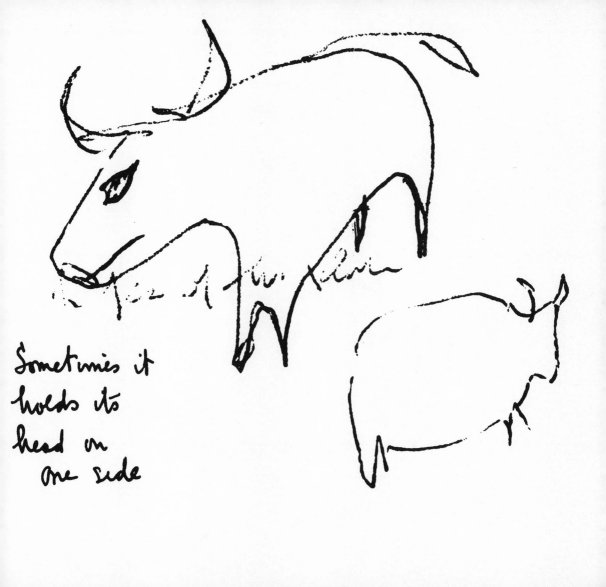

Sometimes it
holds its
head on
one side

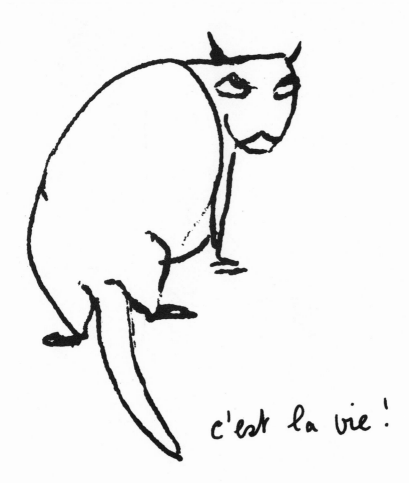

c'est la vie!

My husband
is in Burma.

There are
demons of
various sizes.

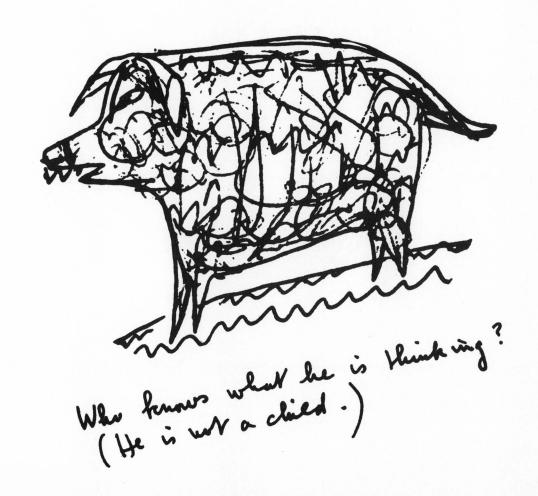

Who knows what he is thinking?
( He is not a child . )

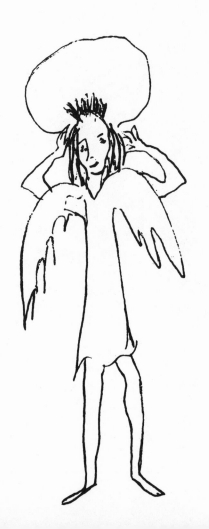

If we have
not this power,
what power
have we?

My little brother
was delicate.

(Her husband the Lord of the Isles is dead, and she lives alone by the Sea)

"Nobody hears me, nobody sees me. My father, the General used to say, he had only to come into a room for everybody to go out of it."

(Ach, wie schrecklich, so alt zu sein! Und diese schreckliche Tränensacke, als wenn sie viel geweint hätte!)

"My heart is a frozen lump.
I look forward to nothing.
Death. I am glad Dad is
Harold is not here to see
me now.

Lord Say-and-Seal, Lord Say-and-Seal,
Why not for once say and reveal
All the dark thoughts your words
                              go over
To make a pretty bog-hole
                              cover!

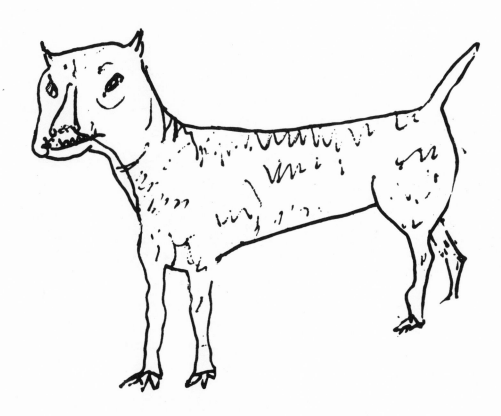

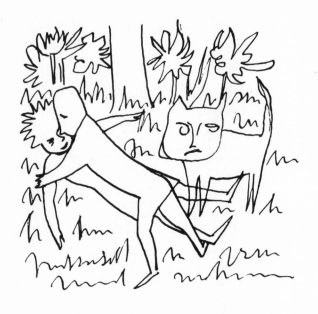

This does not break
down any barriers

Love is everything.

One looks for
it :

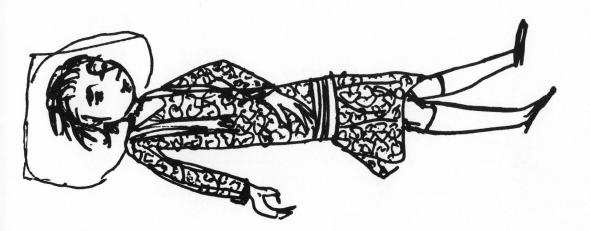

"How will it go?"

"Does it matter?"

"So what!"

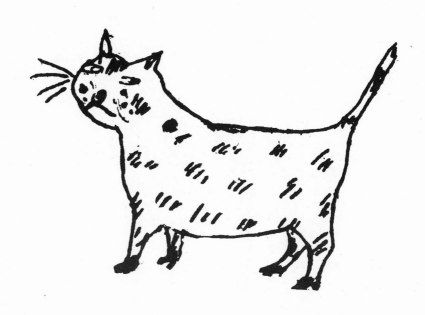

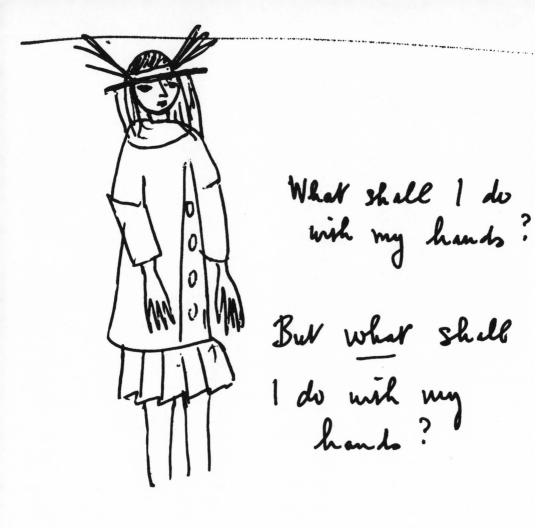

What shall I do
with my hands?

But what shall

I do with my
hands?

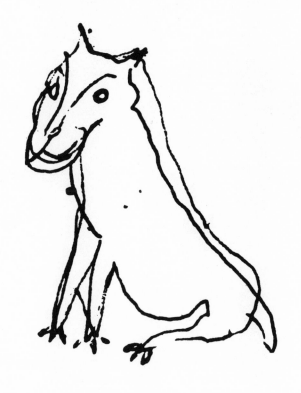

I love and am loved.

Men comfort themselves....

This is rather like Lady Diana.

There are some
human beings
who do not wish
for eternal life

It is the business of a Conservative
Prime Minister to conserve.
I am here to keep
things going. When
my time comes
I shall make
way for
younger
dogs.

It is not my intention to retire.

" I had to be careful
with potatoes.

....The gas fire seemed
quite a friend. Such
a funny little humming
noise. & it had a name, too,
_ 'The Persian', carved on
it, you know _ 'The
Persian'! Ha, ha, ha..."

~~~~~~~~~~~~

Now Agnes, pull yourself
together. You and
 your friends!

We all have these thoughts
Sometimes.

" La Patrie est en danger ! "

"Hail our brave leader!"

"Et cetera!"

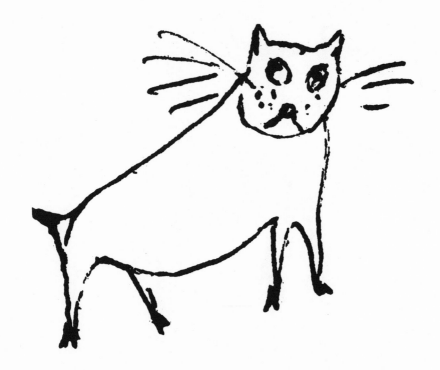

I sometimes thought
 my mind would give way."

I live in the present.

The Countess of Egremont does
not wish for visitors.

lacking the hard stuff
of aristocracy .

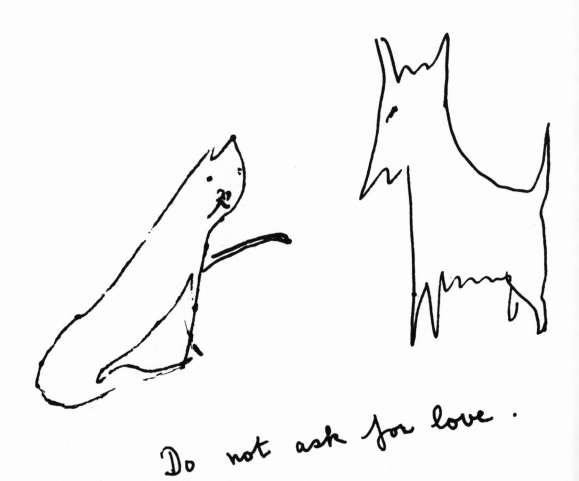

Do not ask for love .

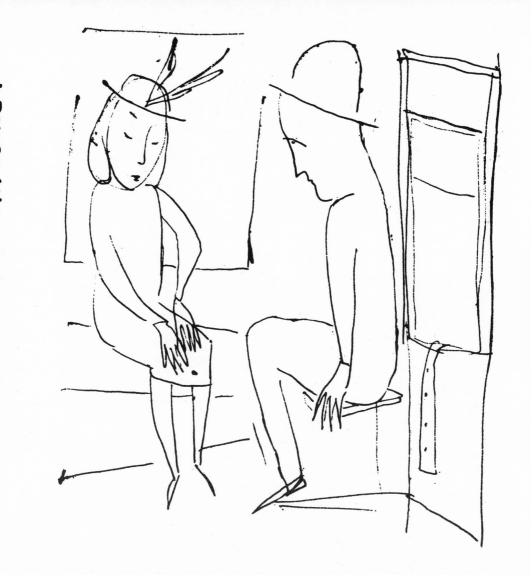

"The silence was extreme."

Nobody
wants to
have a
child
around.

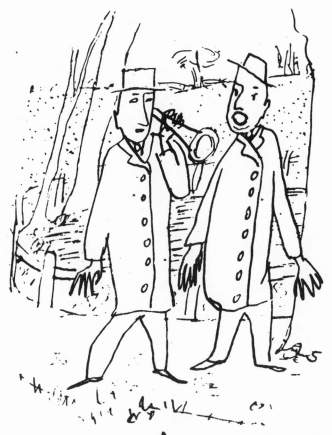

Thus grew up a friendship that endured to the end of their lives.

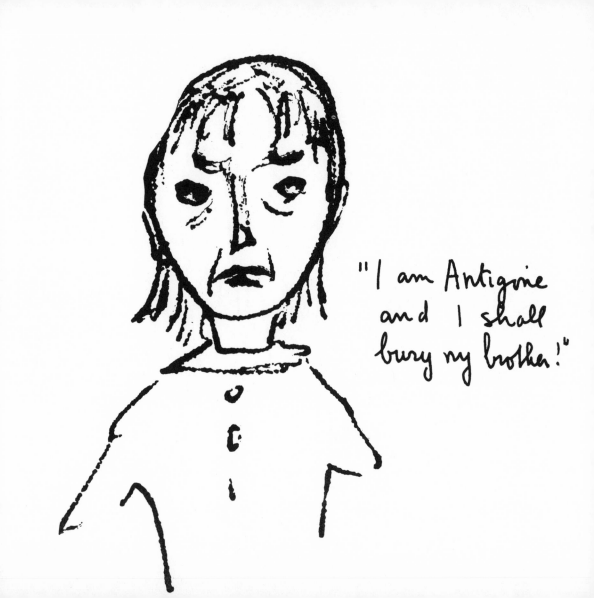

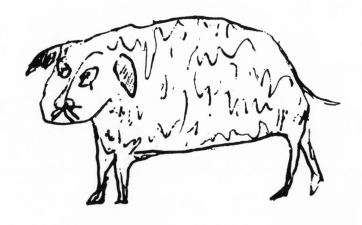

Such an animal is not
responsive to love.

Think !

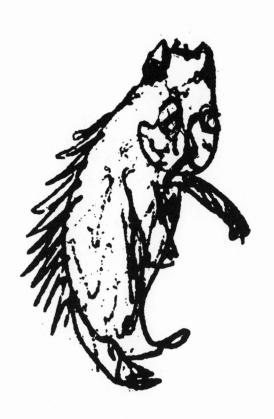

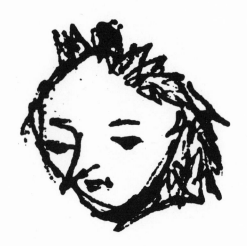

Think !

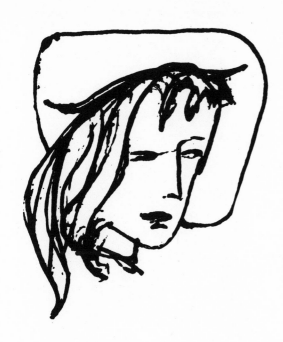

Think twice!

Lord Russell of Liverpool
was brave to tell the truth

Il nous juge !

"I used to think of a little pile of gold."

In yielding and abnegation
I spend my days.

My mother was
a fox.

Orestes, when are you coming?

"It is not easy to be married."

These girls are full of love.

I had a sense of adequacy - nothing more.
I think my husband was happy.

" I am an animal ! "

She is very affectionate .

I am not without friends in
high places.

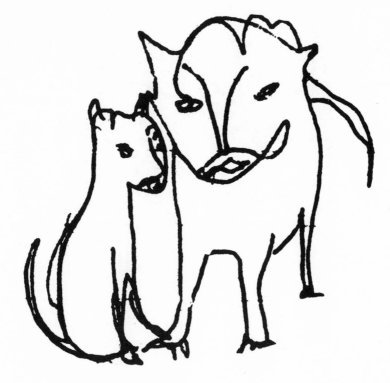

I will tell you everything!

"This beautiful face touches across the centuries, it is so subtle and yielding, yet innocent. Her name is Lucrezia Borgia."

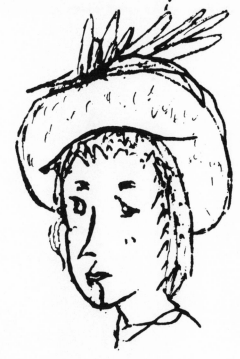

"Yes, I know. I knew her brother once — but only for a short time."

A SEXY OLD CAT

"Ménélas, je suis Hélène et je veux rentrer chez moi !"

"I believe." "I do not"

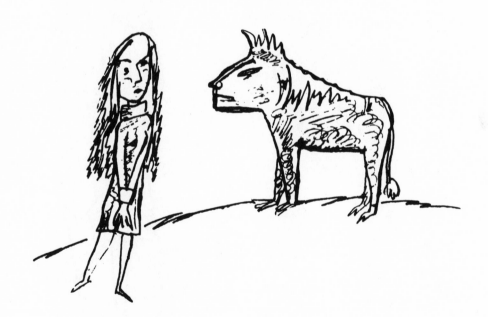

I could
eat you .

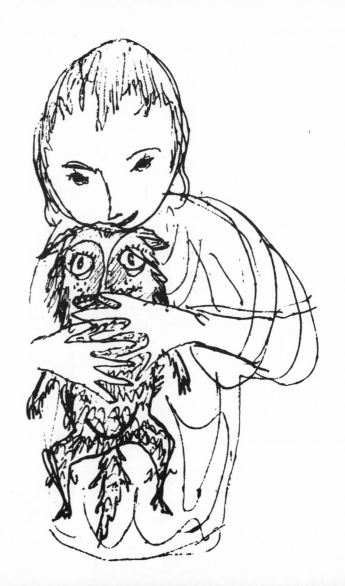

"Everything is swimming in a wonderful
wisdom." (She said everything was swimming
in a wonderful wisdom.")

~~~~~~~~~~~~~~~~~~~~~~~~~~~~~~~~~~~~~~~~~~~~~~~~~~~

"Silly ass!"                              "Her father, they
"What a silly                            say —
woman."                                   "And that funny
"Perhaps she is                          man William."
drunk."                                   "Silly ass."
"No, I think it                          "What a silly
is mescalin."                            woman."
"Silly woman."                           ~~~~~~~~~~~~~~~~~~~~~~
"What a silly
woman."                                  Elle continua
"Yes, perhaps it                         de rire
is mescalin."
"It must be                              comme une
something."                              hyène ---

                                         ~~~~~~~~~~~~~~~~~~~~

"You shnedn't eat pork chops!"
("Doctn said I shouldn't eat pork chops".)

"Doctors have been the cause of many people dying!"

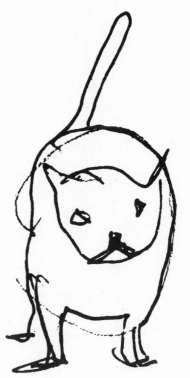

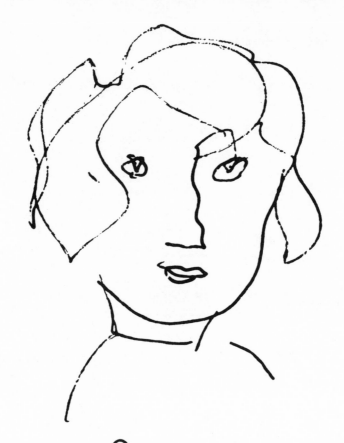

" Je suis Persephone — et je
dois regner ! "

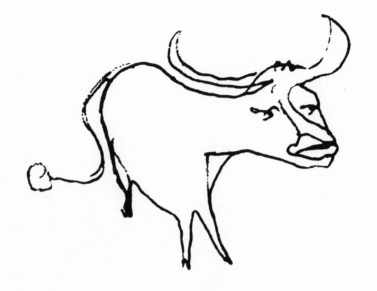

" I find people rather silly."

"I have my feelings!"

I obey a higher law.

Les âmes profondément
bonnes sont toujours
indécises .

I was alive and am dead

Wag. wag!

"We all have to go some time."